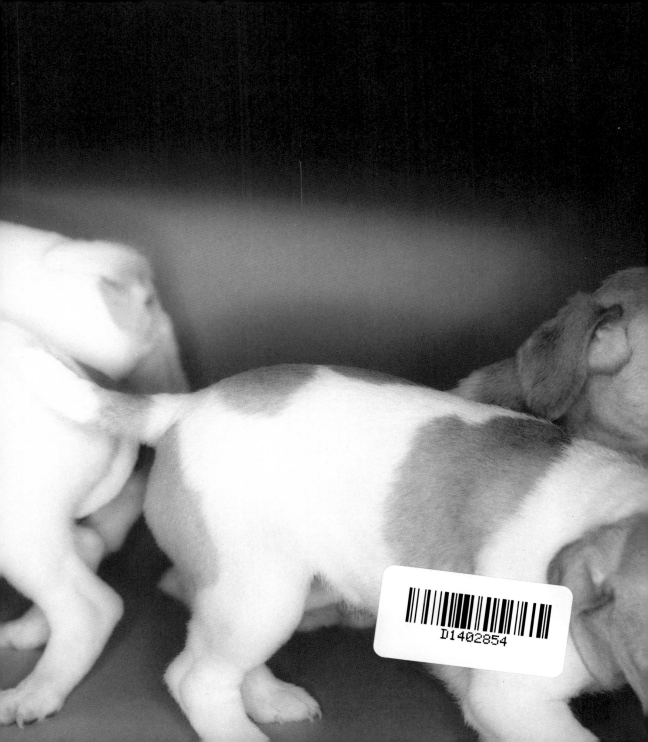

14,95

Pup

Pup

by Deborah Samuel

CHRONICLE BOOKS
SAN FRANCISCO

Library of Congress Cataloging-
in-Publication Data:
Samuel, Deborah.
Pup/by Deborah Samuel. p.cm.

ISBN 0-8118-3362-3
1. Puppies. 2. Puppies—Pictorial
works. I. Title.

SF426.2.S25.2002
636.7'07'0222dc21—2001042367

Manufactured in China.

Prints from *Pup* available at
www.deborahsamuel.com

 Herter Studio
432 Elizabeth Street
San Francisco, CA 94114
www.herterstudio.com

Producer
Caroline Herter, Herter Studio

Project Editor
Debbie Berne

Design
Jana Anderson, studio A

Copy Editor
Kathleen Erickson

Distributed in Canada
by Raincoast Books
9050 Shaughnessy Street
Vancouver, British Columbia
V6P 6E5

10 9 8 7 6 5 4 3 2 1

Chronicle Books LLC
85 Second Street
San Francisco, California 94105

www.chroniclebooks.com

for my sisters
and brothers

Lorraine, Craig, Roderick,
Annellie, Kirei, and Lara

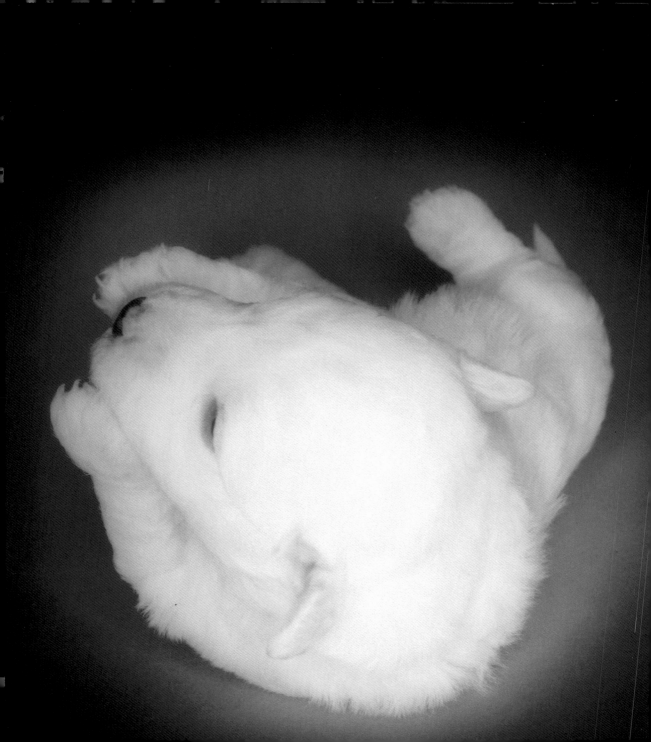

Madeline

Bichon Frise
16 days
1½ pounds

The love you give your puppy,

the dog will return a
hundredfold.

Bounce

Jack Russell
5 months
12 pounds

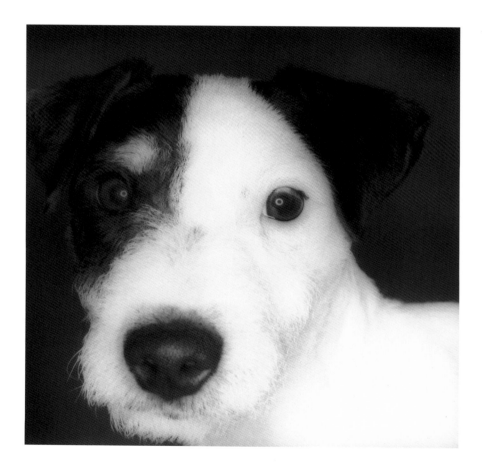

Bud Jr.

Boston Terrier
4 weeks
3 pounds

Bud Jr. and Family

Boston Terriers
4 weeks
3 pounds each

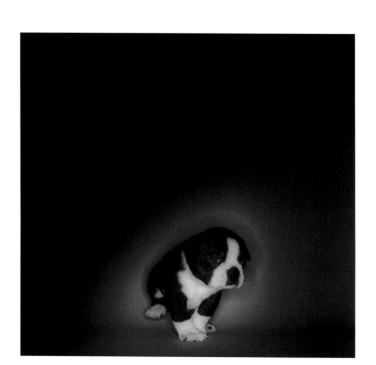

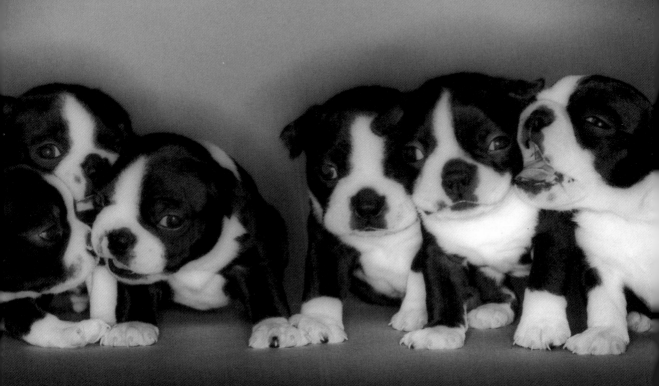

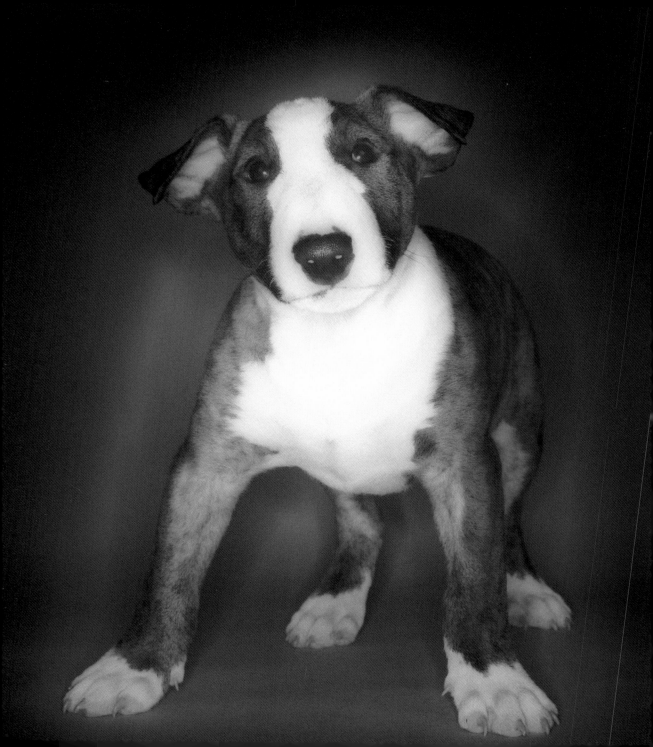

Lulu Belle

English Bull Terrier
4½ months
15 pounds

Lulu hates waking up.

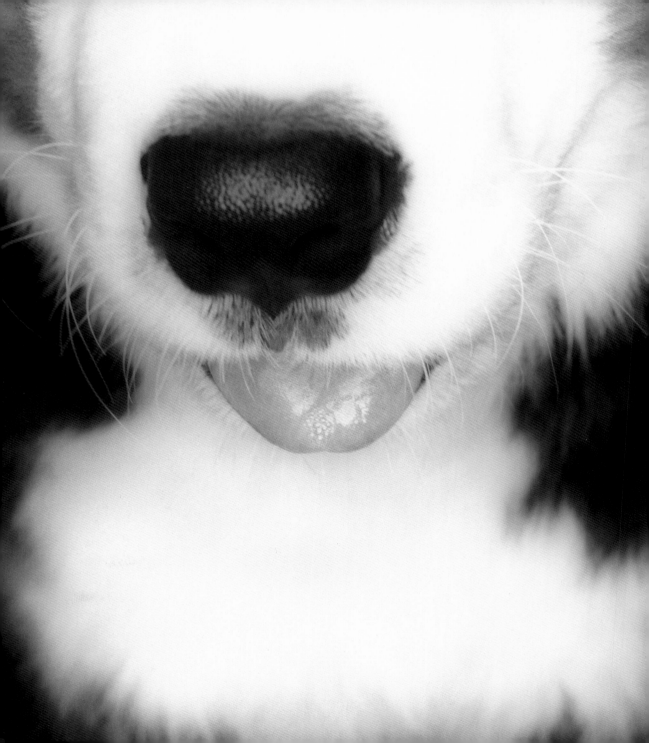

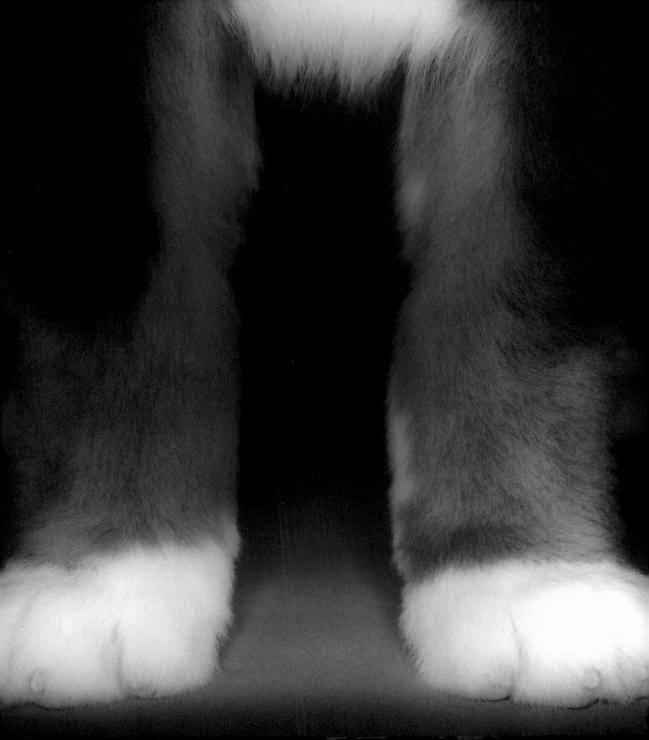

Bernie
(preceding pages)

Bernese Mountain Dog
10 weeks
20 pounds

Moses

Dogo Argentina
7 months
98 pounds

16

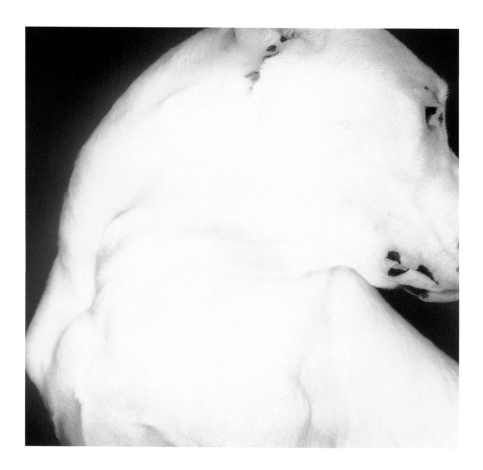

Madison

Basset Hound
6 months
25 pounds

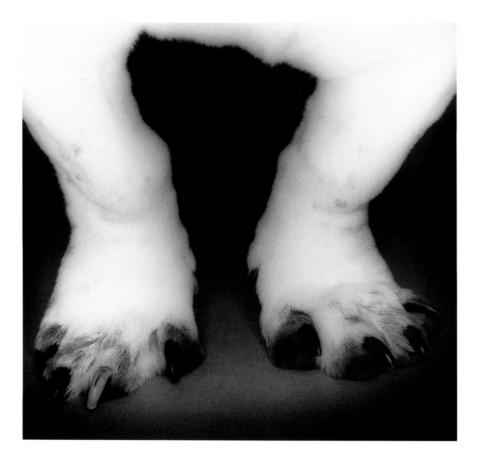

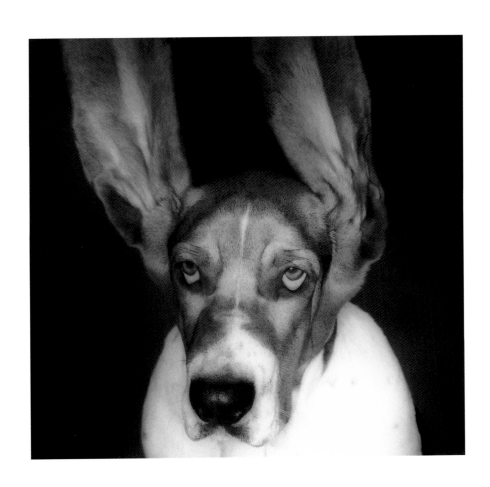

Sugar

Samoyed
11 weeks
12 pounds

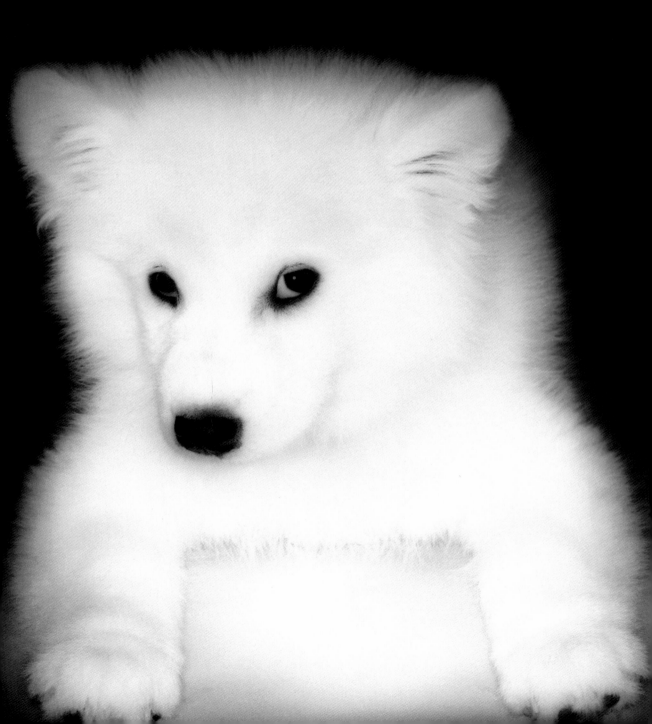

Astro

Shiba Inu
5 months
15 pounds

22

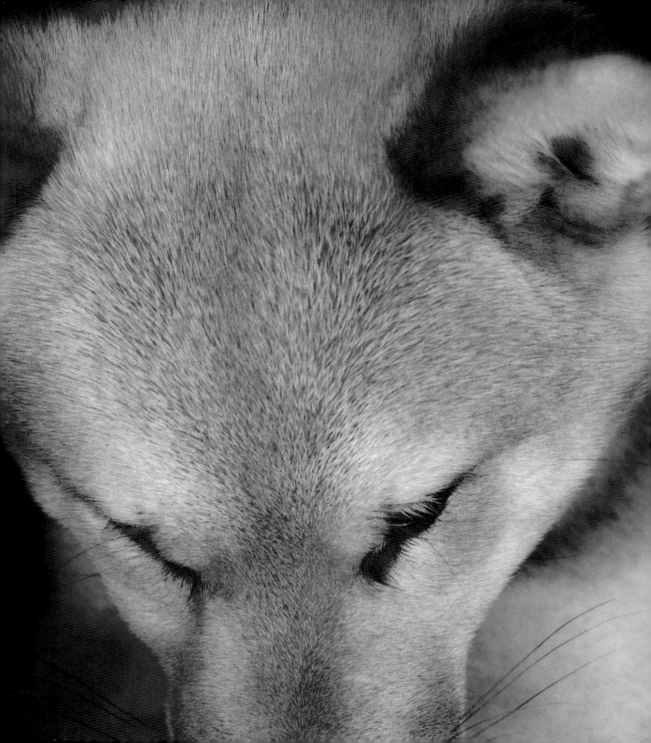

Spike

Miniature Pinscher
8 months
6½ pounds

Spike has a great **big dog** inside of him.

Spike

Miniature Pinscher
8 months
6½ pounds

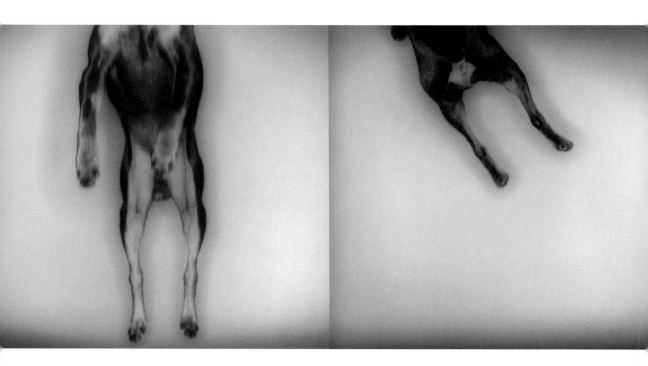

Makita wants to do two things: *fetch and swim,*

fetch and swim,

fetch and swim.

28

Makita

Labrador Retriever
9 weeks
12 pounds

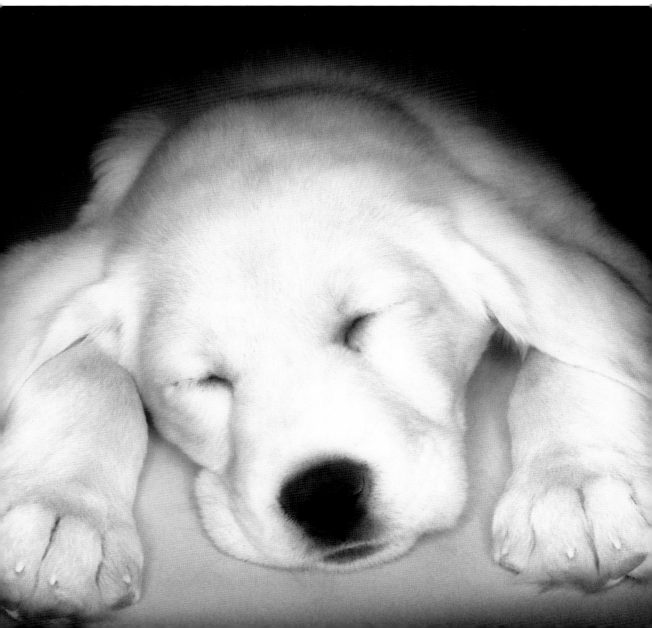

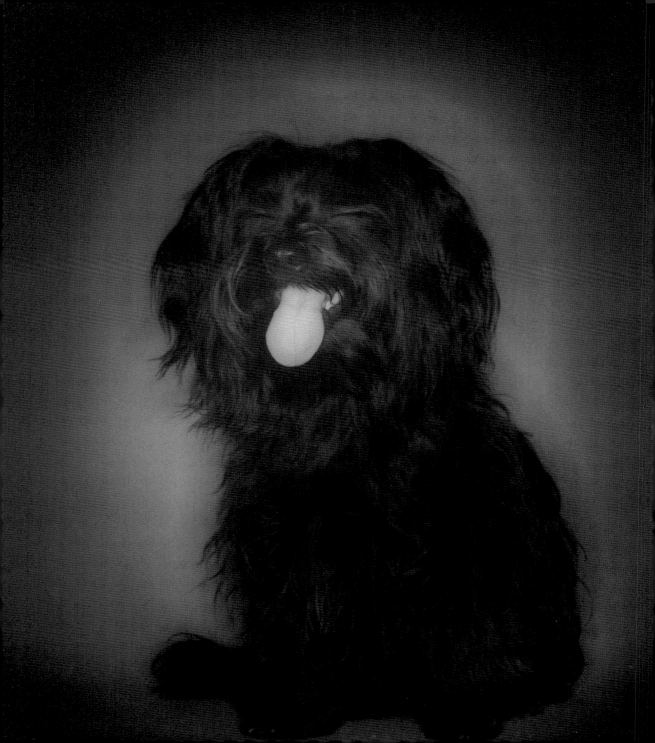

Diva eats lip gloss.

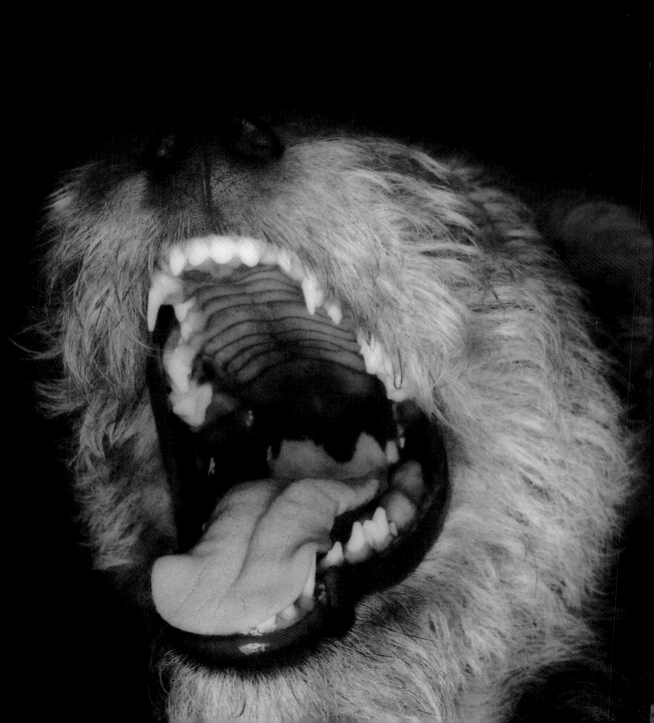

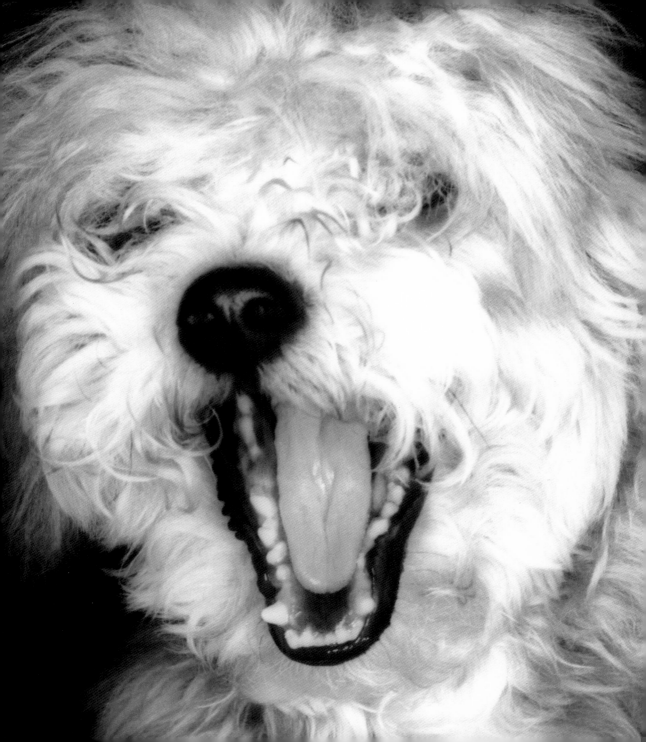

Enzo
(preceding page, left)

Welsh Terrier
4½ months
12 pounds

Guga
(preceding page, right)

Lhasa Apso
8 months
5 pounds

Waggz and Tag

Border Collies
4 months
16 pounds each

Tag, Zak, Waggz, and Torrie

Border Collies
4 months
16 pounds each

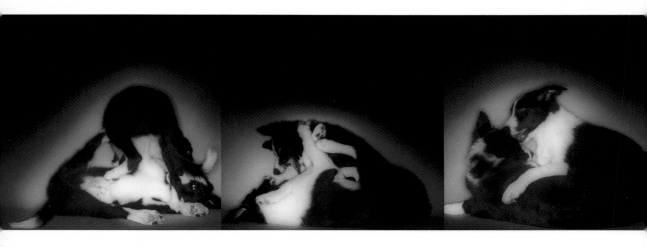

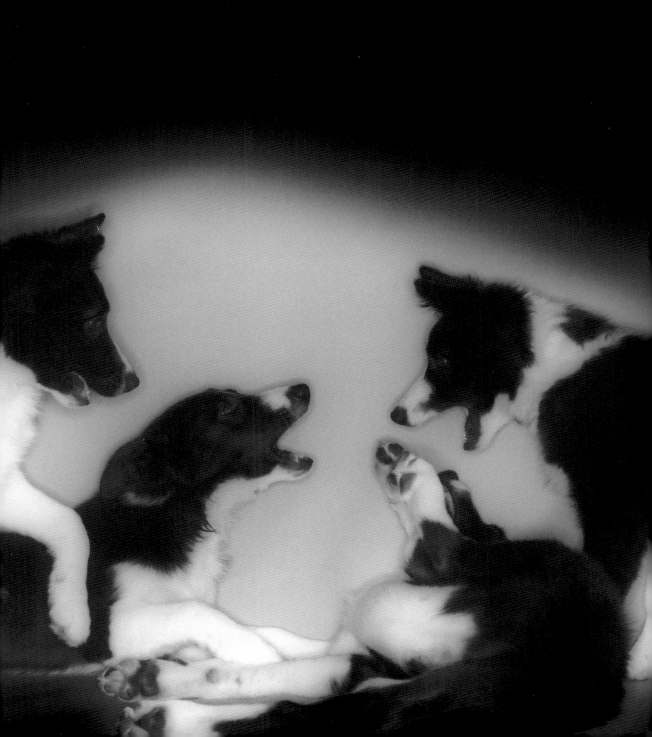

Brawlie

Rottweiler
12 ½ weeks
25 pounds

36

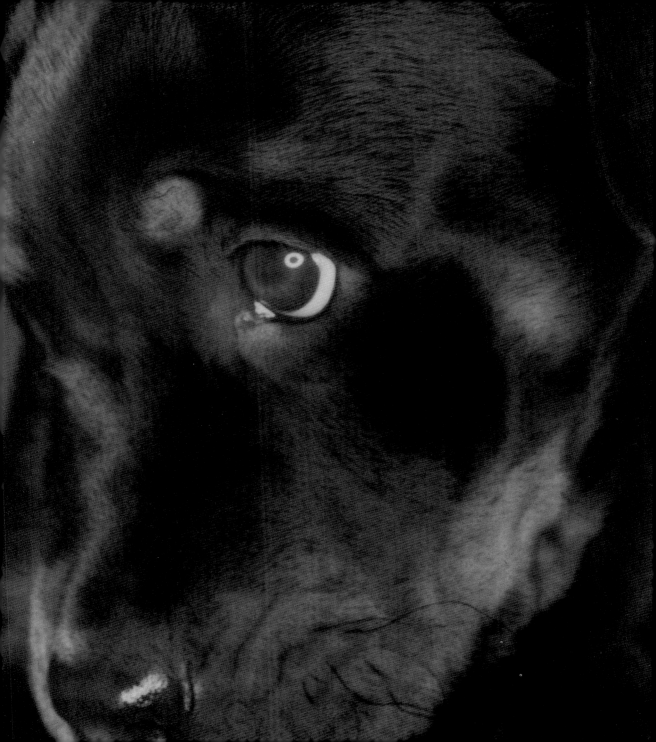

Dodger

Beagle
10 weeks
8 pounds

Orbit

Jack Russell
4, 8, and 22 weeks
3, 5, and 10 pounds

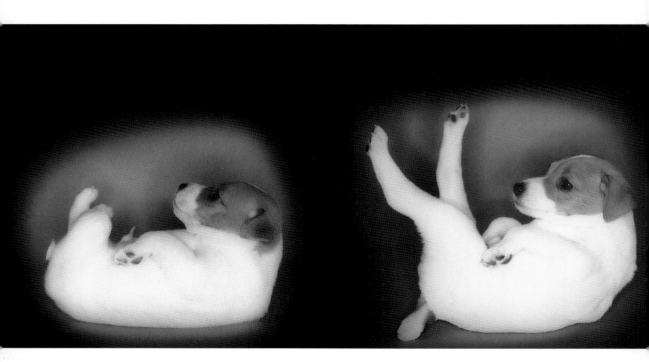

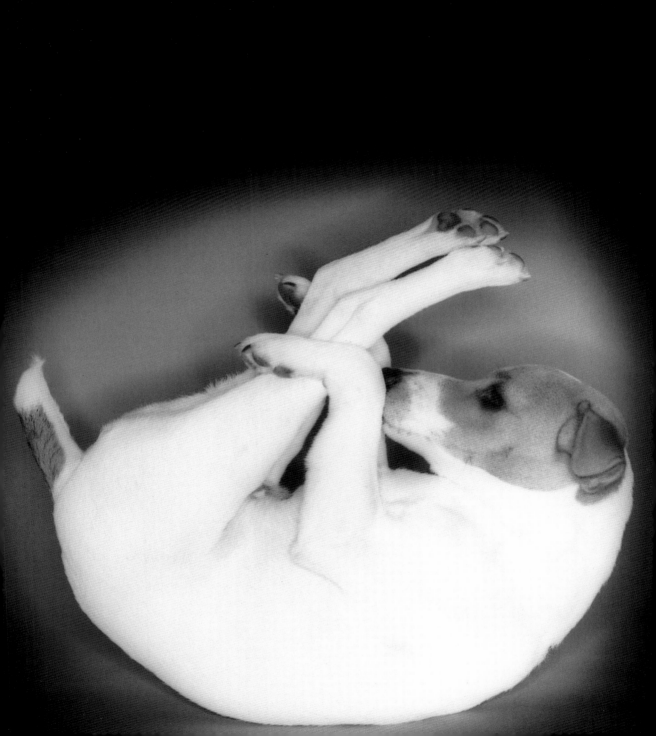

42

There are two Parkers: "I just woke up and I'm going to raise hell" Parker and "I'm getting sleepy, hold me, aren't I cute?" Parker.

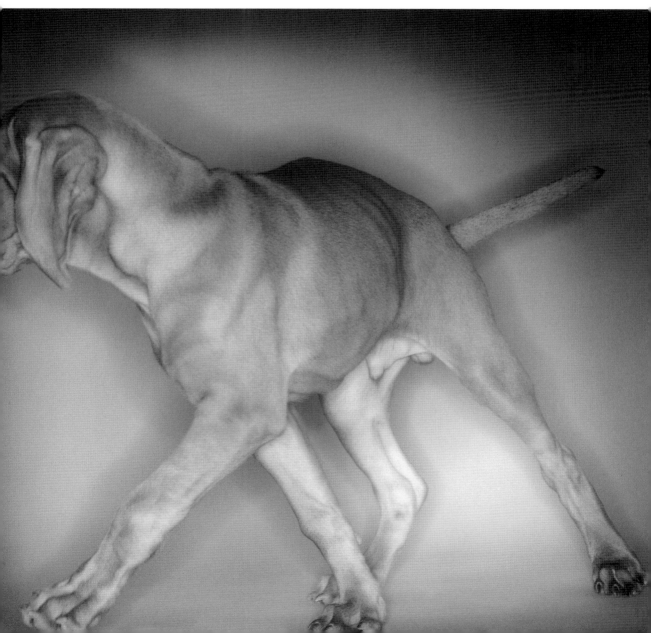

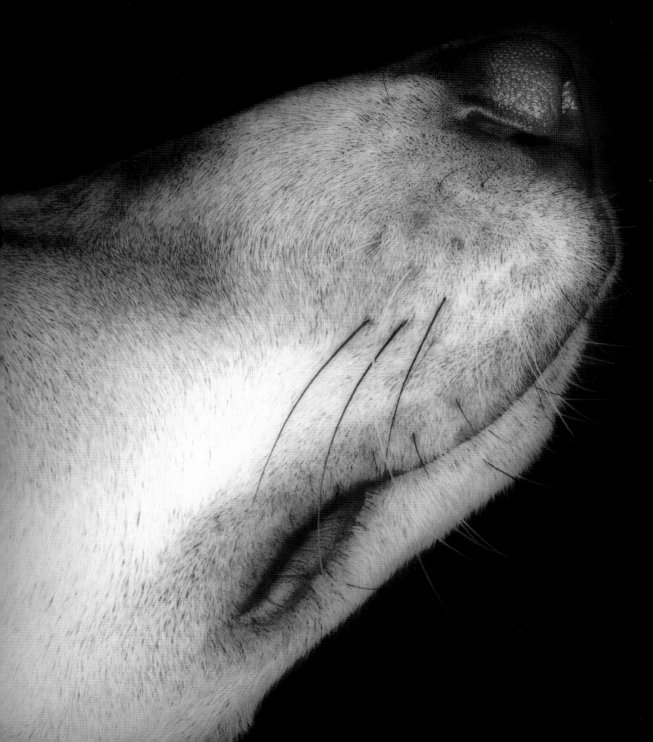

Alexi

Catahoula Leopard Dog
5½ months
40 pounds

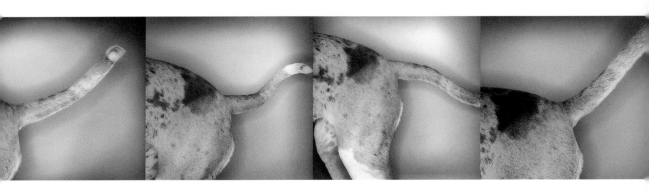

Rambo *steals* underwear.

Rambo
Chihuahua
1 year
5 pounds

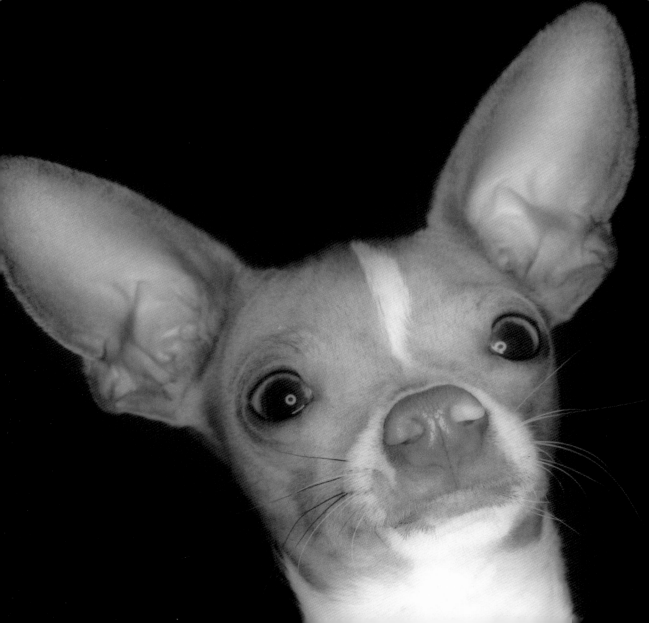

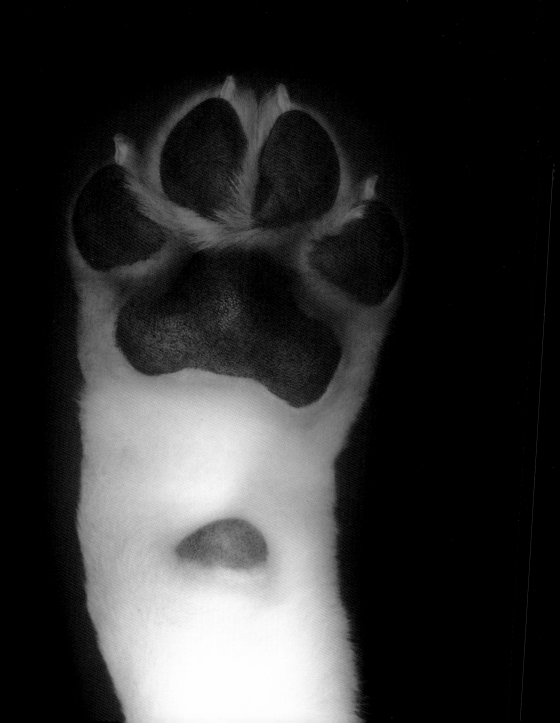

Georgia Peach

Labrador Retriever
9 weeks
20 pounds

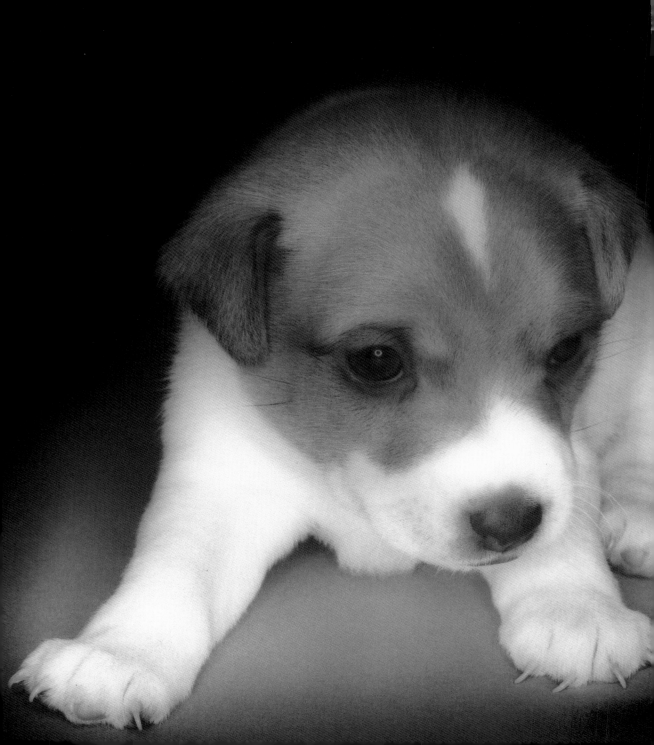

Orbit

Jack Russell
4 weeks
3 pounds

Oscar

Jack Russell
4 days
10 ounces

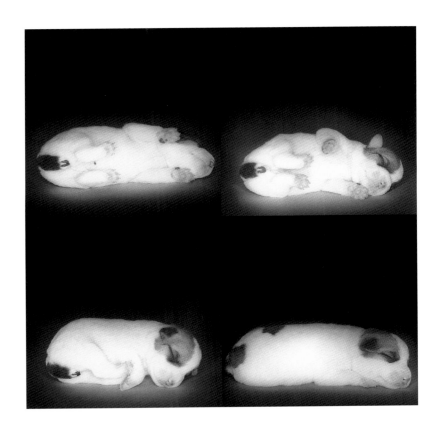

Flash
Boxer
7 months
50 pounds

Flash lives with a **cat** who wants nothing to do with

him.

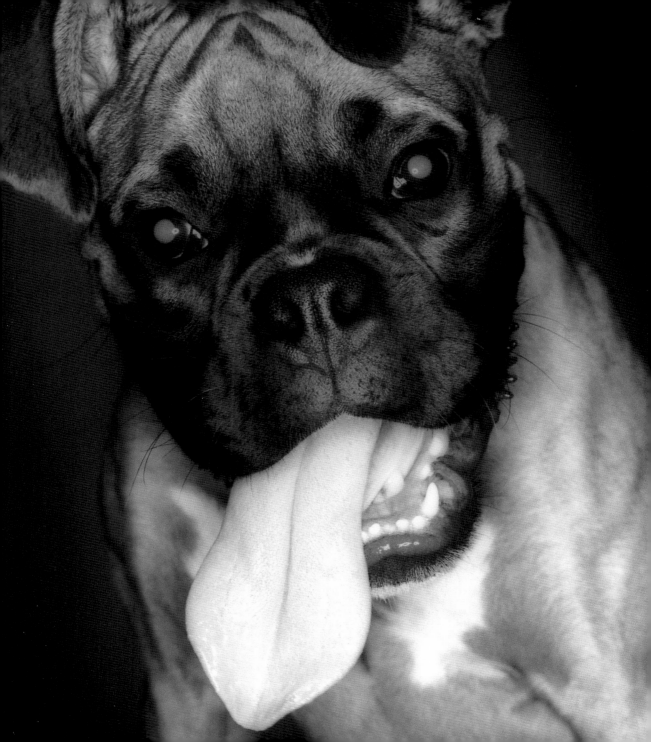

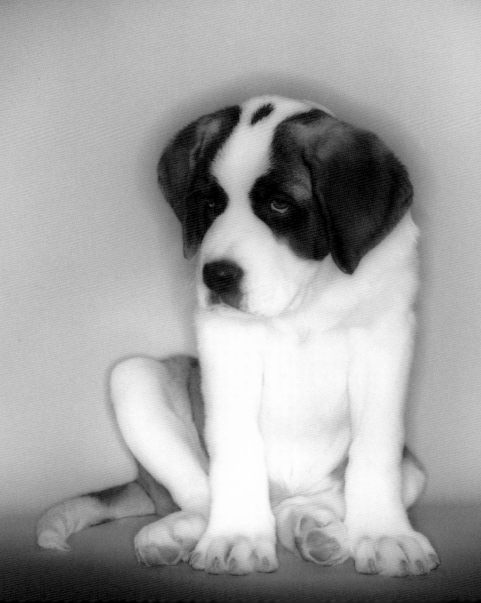

Rocket

Saint Bernard
12 weeks
31 pounds

Dodger

Beagle
10 weeks
8 pounds

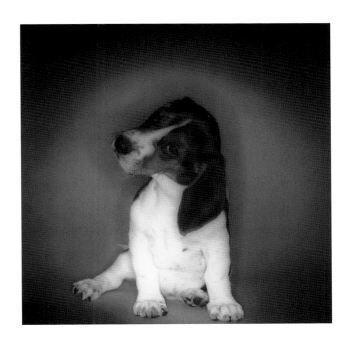

Brawlie

Rottweiler
12½ weeks
25 pounds

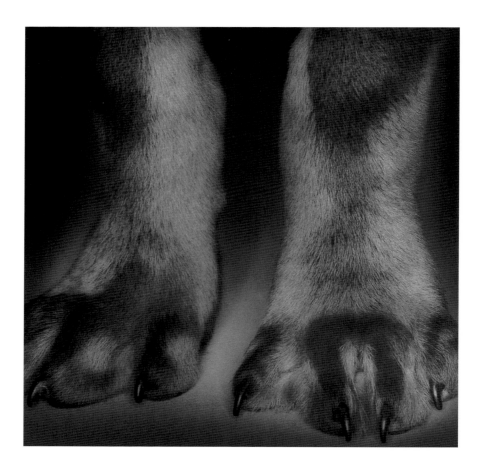

Angel

German Shorthaired Pointer
5 months
20 pounds

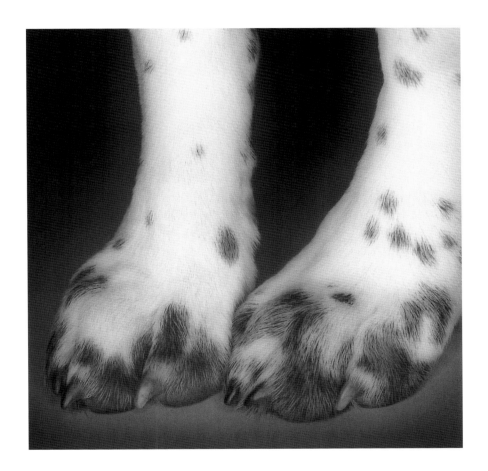

Samantha

Cocker Spaniel
12 weeks
7 pounds

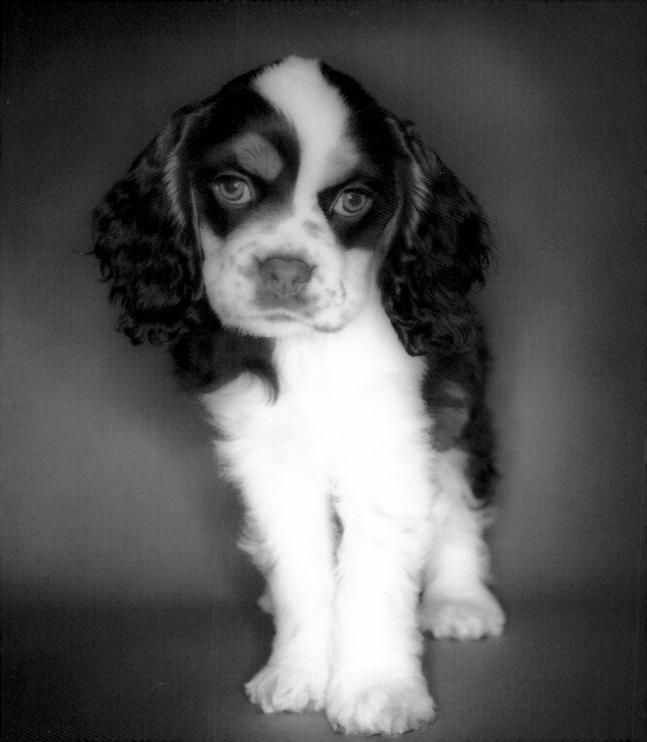

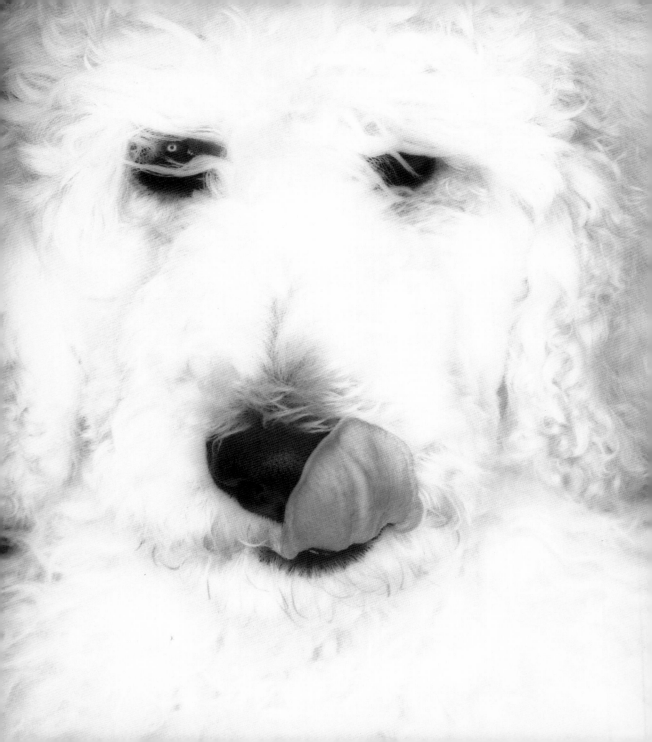

Margot

Standard Poodle
14 weeks
20 pounds

Margot adores men.

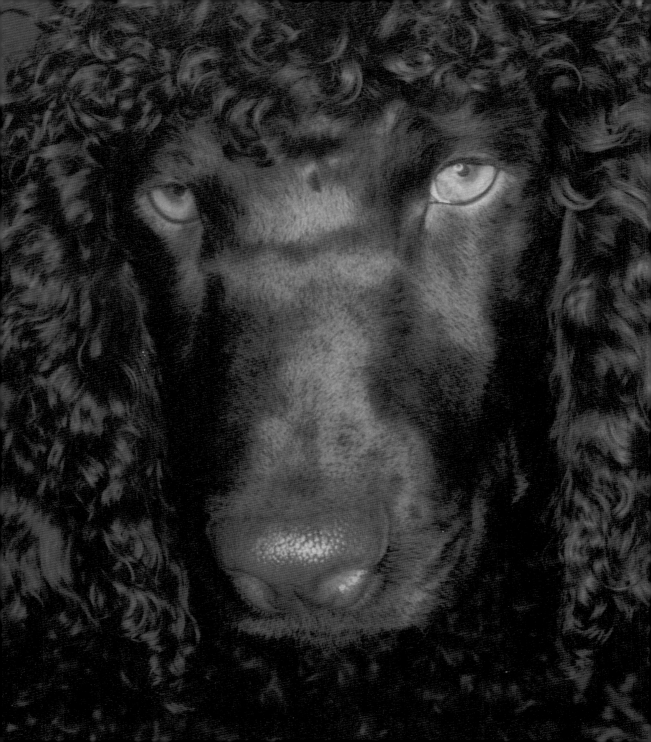

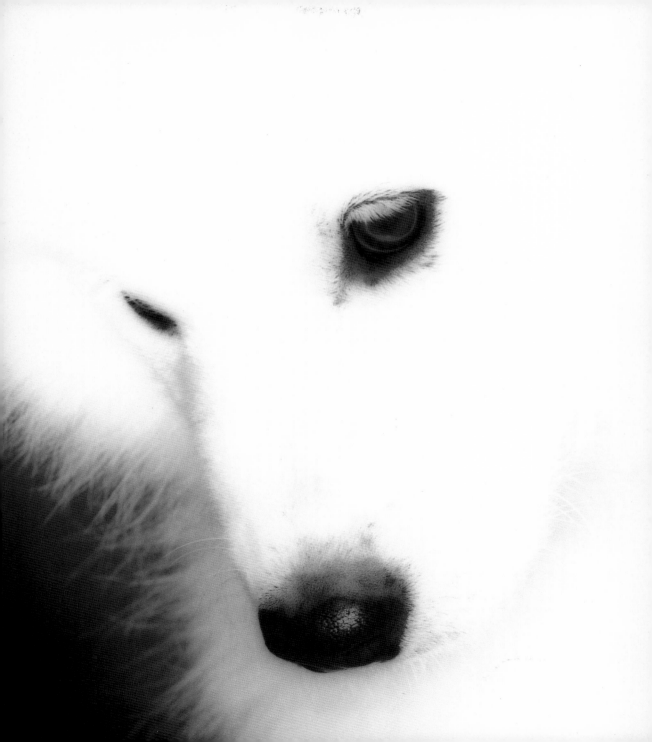

Phineas
(preceding page, left)

Irish Water Spaniel
4½ months
30 pounds

Bear
(preceding page, right)

Samoyed
14 weeks
20 pounds

Rudy

Border Terrier
5 months
11 pounds

Rudy drags dirty clothes

a r o u n d

the house.

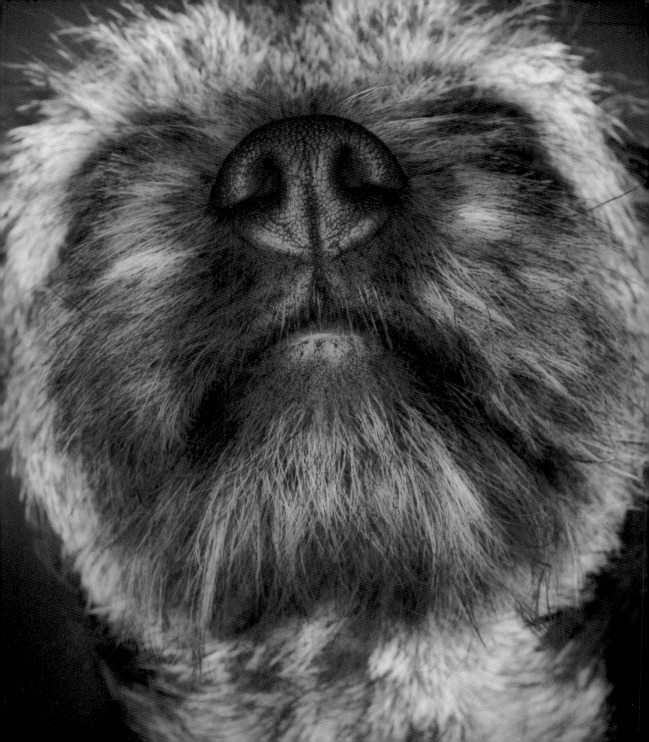

Margot

Standard Poodle
14 weeks
20 pounds

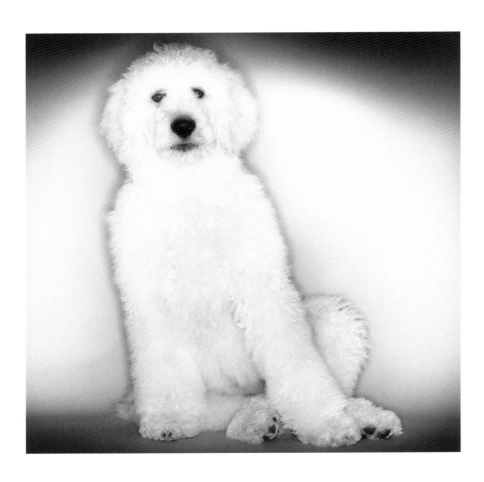

Zoe
Australian Cattle Dog
5½ months
21 pounds

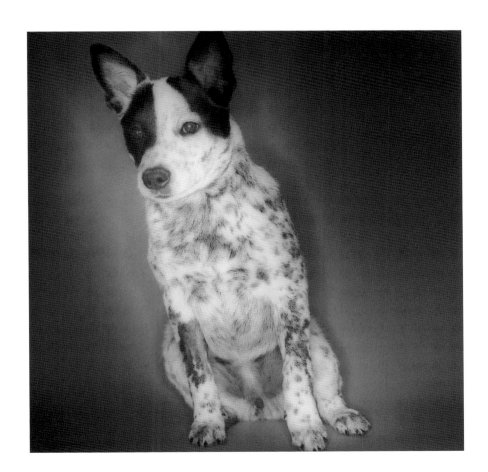

Zor

Great Dane
7 weeks
17 pounds

68

Zor

loves

to

watch

the

toilet

flush.

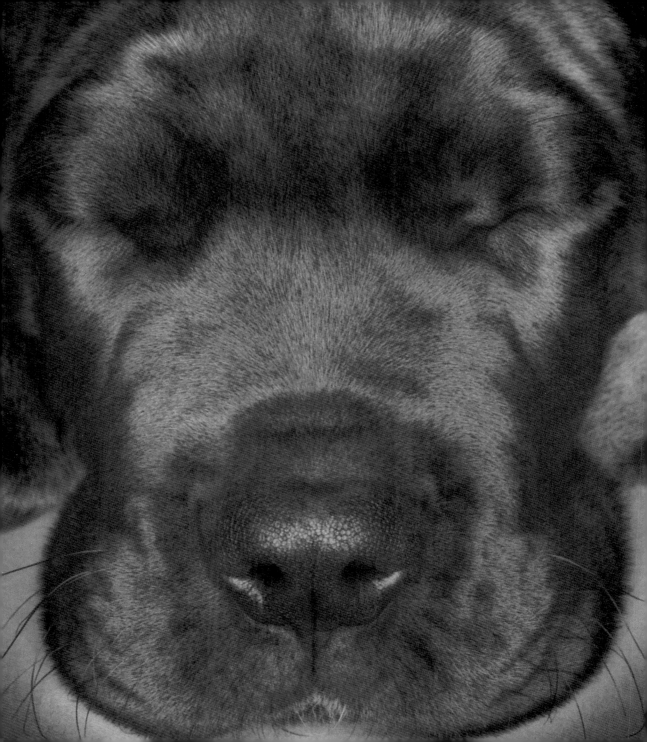

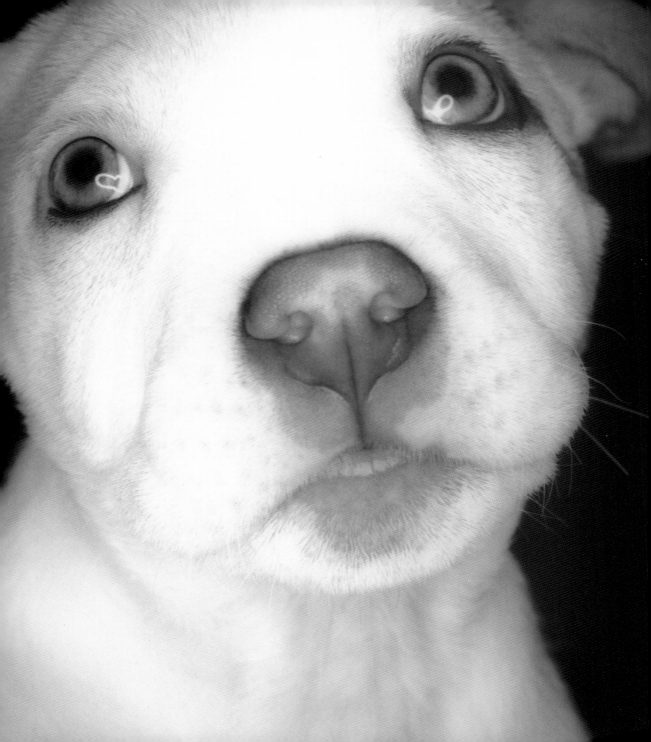

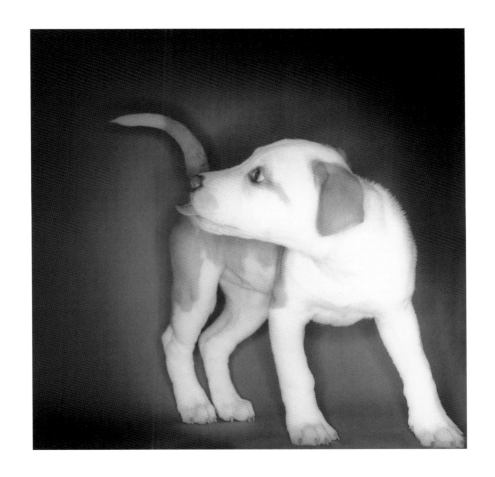

Charlie

Pit Bull Terrier
9 weeks
10 pounds

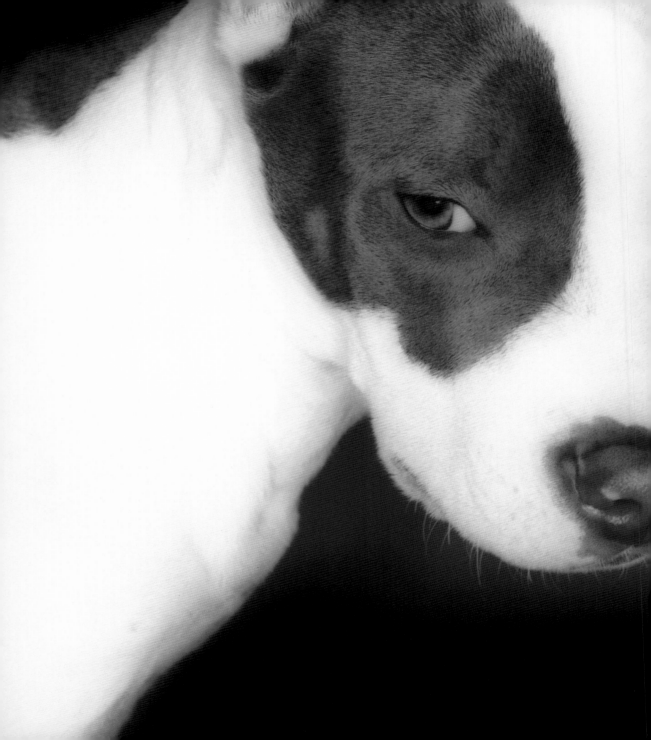

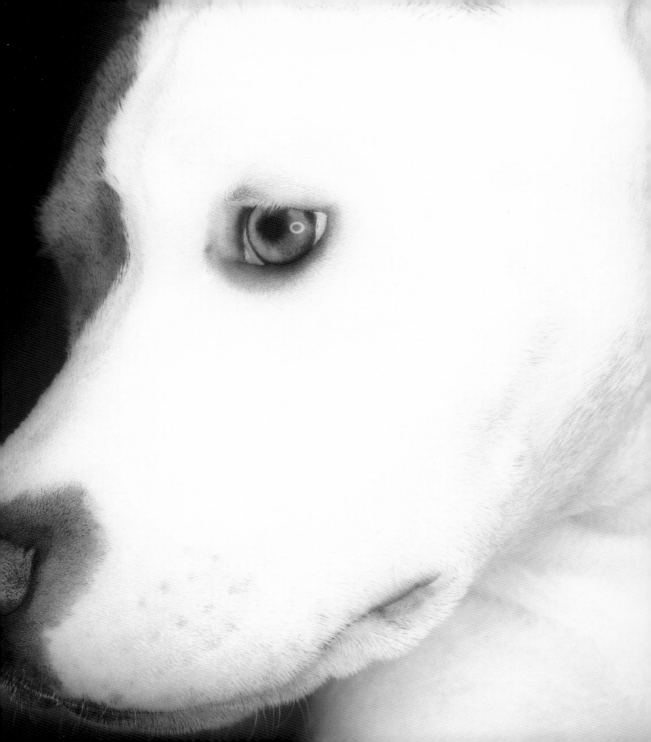

Nikita
(preceding pages)

Pit Bull Terrier
15 weeks
37 pounds

Olivia and Orbit

Jack Russells
4 weeks
3 pounds each

Orbit and Olivia sit

in the sun *&* watch the world go

by.

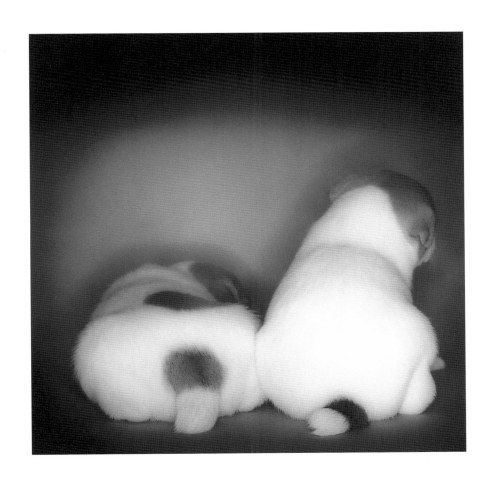

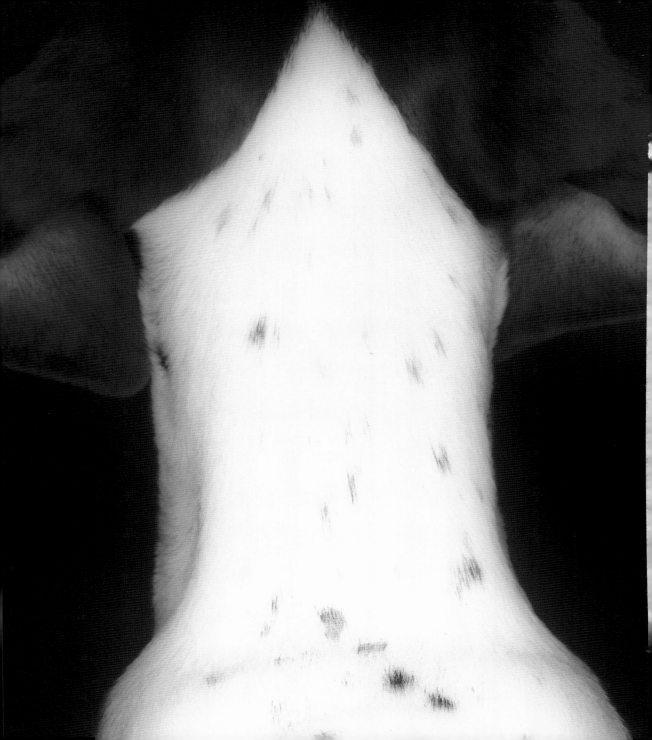

Index by breed

Angel

German Shorthaired Pointer
5 months
20 pounds

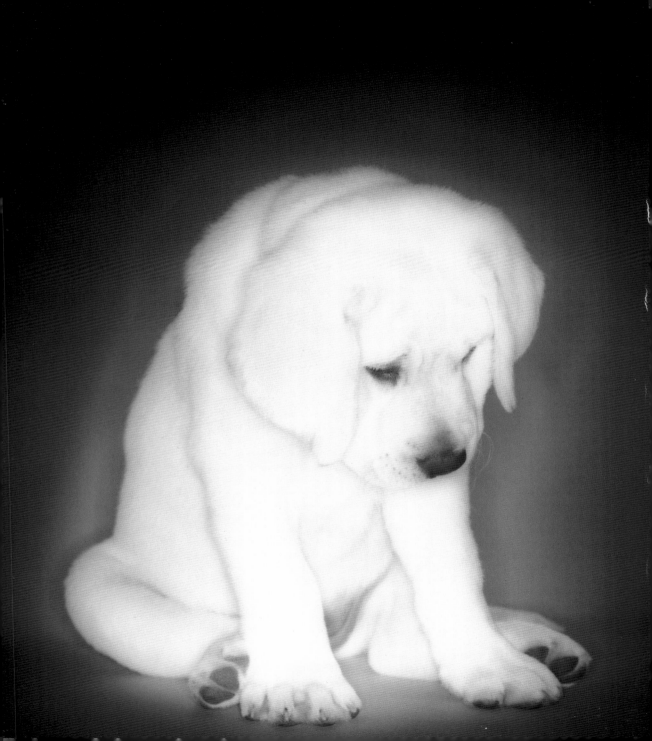

Acknowledgments I would like to thank everyone who has assisted in this project, especially
 Karen Van Hoy, Kathryn Lissa Thomas, Wency Lopez, Lisa Anne Kelly,
 Florence Belcher, Annabelle at Little Dog House, Scott Cummins,
Barbara at A-1 Laudro-Mutt, Three Dog Bakery, and to everyone at White's Pet Hospital
for all your help in locating puppies.

Thank you to all the owners for their efforts and for giving me the opportunity to share
their puppies for a short time.

Thank you to Chris Kewbank and Catherine Turner at Special Photographers Co.;
Ethylene Staley and Taki Wise at Staley Wise Gallery; all at Fine Print, especially Kate
Dardine; Joyce Sipple; Nina Munk; the Basenji Sisters; all at Samy's Camera Santa
Barbara, especially John Branard, Kerry Buckland, and Glenda Hernandez; Lesley Sparks,
Dr. Dan Causaus, and all at White's Pet Hospital; Dr. Ken Bruecker; Dr. Michael Broome;
and Ted Baer for all your help and care.

Thank you Carmen Dunjko, Coleen Quinn, Gerrie Shapiro for Moses, the Girls in
Ireland, Mr. Shine, the Kenny Club, Roger and Rilla Mulligan, and Dave Gray and
Anne Stephens for your friendship. Thank you Steve Donolo for believing, Eirini
Demetelin for always keeping me informed, Colette Baron Reid for always keeping me
tuned in, and Ellen Croft for dropping by in her hat.

Thank you to my assistants: Keegan Fitch for months of retouching without a whimper,
Jean Lin for wrestling with countless files, and Mary Ellen Rogusky for her ability to
produce the strange sounds that fascinated the puppies in this book.

Sincere thanks to Caroline Herter and Debbie Berne at Herter Studio; to Jana Anderson
at studio A design; and to Jack Jensen, Mikyla Bruder, Pamela Geismar, Shona Bayley,
Jodi Davis, Sarah Bailey, Jane Steele, Laurel Rivers, and Steve Kim at Chronicle Books
for your passion, expertise, and patience in producing this project.

Thank you to my loved ones: my husband, Rey Villalobos; and Rey, Gina, and Meece
Villalobos; Jake, Lucy, and Petey; Dolores Henderson; Lex and Cole Samuel; Ashley
and Cy Clusiaus; Luke Chudoba; and Jeffrey Levy.

With love to my mother and father and extended family, especially to my sisters and
brothers who have each enriched my life in immeasurable ways.

Georgia Peach

Labrador Retriever
9 weeks
20 pounds

Guga

Lhasa Apso
8 months
5 pounds

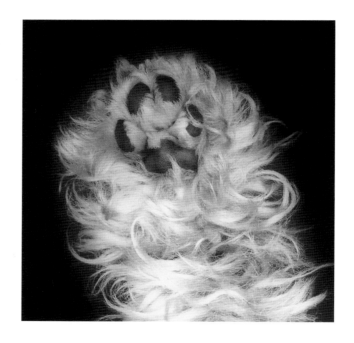